STRANGE PLANET
EXISTENCE CHRONICLE
BY NATHAN W PYLE

I MUST
WRITE DOWN
MY THOUGHTS

WM
MORROW
GIFT

THIS JOURNAL BELONGS TO

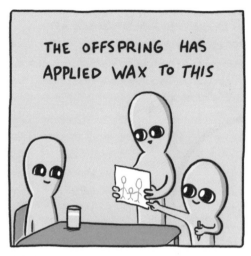

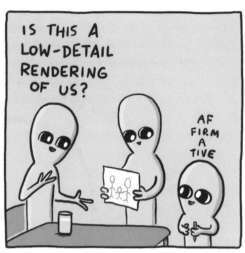

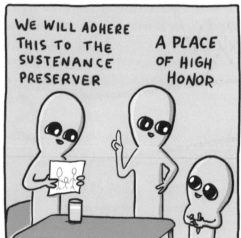

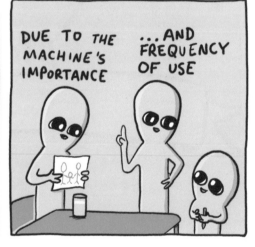

DRAW A LOW-DETAIL RENDERING OF YOUR FAMILY

DESCRIBE EACH MEMBER OF YOUR FAMILY (INCLUDE ANY CREATURES)

FILL IN ALL OF THE LOW-DETAIL RENDERINGS ON THIS SUSTENANCE PRESERVER

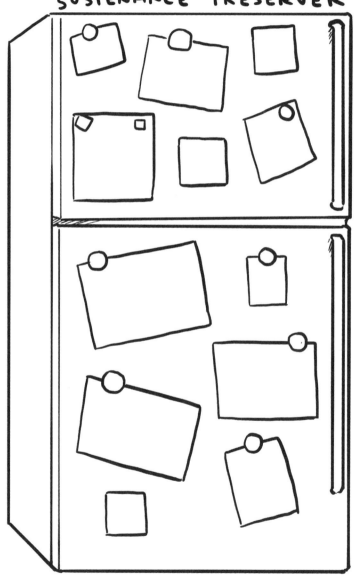

DRAW THE MOST CRUCIAL
ITEMS IN YOUR SUSTENANCE
PRESERVER

WHAT MAKES YOU REACT
THIS WAY?

DESCRIBE AN EXPERIENCE
THAT LEFT YOU SPEECHLESS

GROWN BEINGS
MUST CHOOSE
WHICH TASKS THEY
WANT TO DO
INCORRECTLY

DESCRIBE A TIME YOU REACTED
THIS WAY

WHAT WERE SOME
MISCONCEPTIONS YOU HAD
ABOUT GROWN BEINGS WHEN
YOU WERE YOUNG?

DESCRIBE A DAY FULL OF ENJOYMENT

STAR
RISE

MID
DAY

STAR
FADE

DRAW YOUR FOUR MOST RELAXING ACTIVITIES

DESCRIBE EACH ONE
IN DETAIL

1

2

3

4

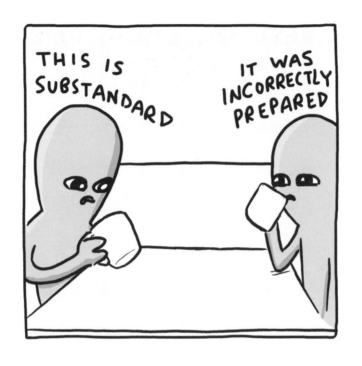

WHAT MAKES YOU REACT
THIS WAY?

WHAT SUSTENANCE DO
YOU CONSIDER YOURSELF A
CONNOISSEUR OF?

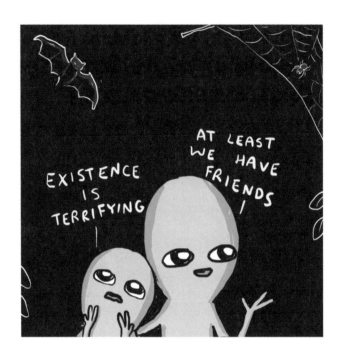

WHAT WERE YOU FEELING WHEN YOU REACTED THIS WAY?

WHAT WAS THE MOST
TERRIFYING LOCATION YOU
HAVE VISITED?

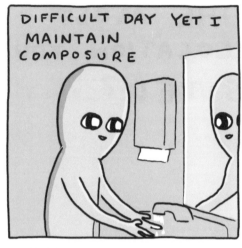

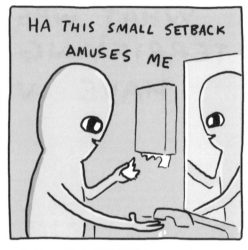

DESCRIBE A DAY WHEN MANY
SMALL SETBACKS PUSHED YOU
TO YOUR EMOTIONAL LIMIT

LIST FIVE SMALL SETBACKS
THAT CAN MAKE YOUR DAY WORSE

1

2

3

4

5

LIST FIVE SMALL EVENTS THAT CAN IMPROVE YOUR DAY

1

2

3

4

5

DESCRIBE A TIME YOU REACTED
THIS WAY

DESCRIBE A TIME YOU
SUCCEEDED DESPITE BEING
WILDLY UNPREPARED

WHAT MAKES YOU REACT THIS WAY?

WHAT IS SOMETHING MINOR
THAT MAKES YOU
DISPROPORTIONATELY MAD?

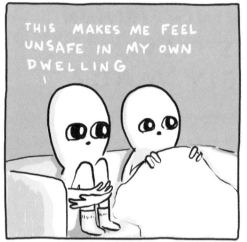

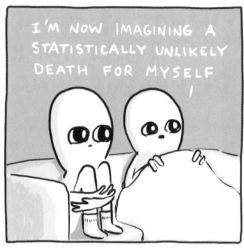

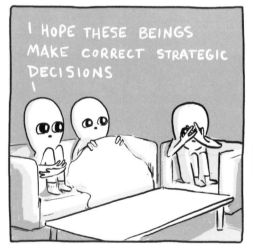

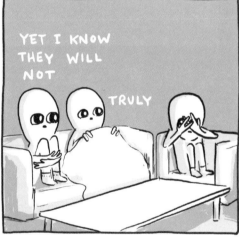

HOW MUCH DO YOU ENJOY TERRIFYING
FICTIONAL NARRATIVES?

MARK WITH AN X

CONSUME
NONE

CONSUME
ALL

DESCRIBE THE MOST TERRIFYING
FICTIONAL NARRATIVE YOU
ENJOYED

DESCRIBE YOUR BEST STRATEGIES FOR SURVIVING A TERRIFYING FICTIONAL NARRATIVE

①

②

③

④

⑤

⑥

DESCRIBE A FICTIONAL CHARACTER
THAT FRIGHTENS YOU

DRAW THE CHARACTER
CHASING YOU

WHAT MAKES YOU REACT
THIS WAY?

IF YOU COULD CONSUME ANY DESSERT IN ANY LOCATION, WHAT WOULD YOU CHOOSE?

WHAT WERE YOU FEELING
WHEN YOU REACTED THIS WAY?

WHAT KIND OF PRODUCTIVE DISCOMFORT ARE YOU MOST COMFORTABLE WITH?

DRAW THE NEMESIS SUSTENANCE
OF YOUR CHILDHOOD

DESCRIBE THE LENGTHS YOU WOULD
GO TO IN ORDER TO AVOID IT

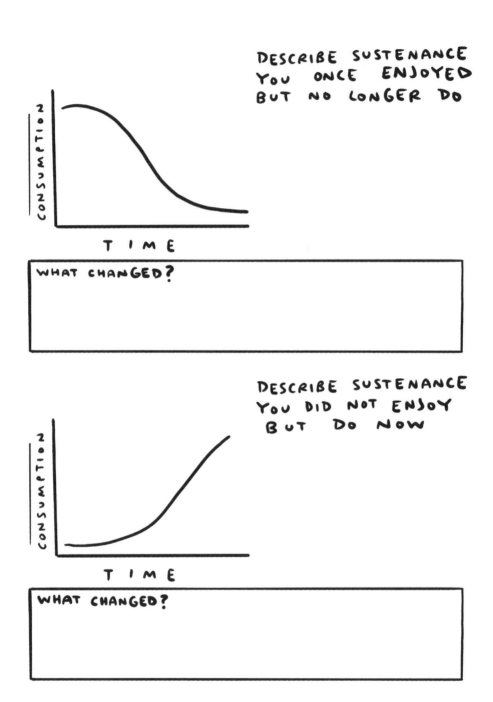

DESCRIBE SUSTENANCE YOU ONCE ENJOYED BUT NO LONGER DO

CONSUMPTION

TIME

WHAT CHANGED?

DESCRIBE SUSTENANCE YOU DID NOT ENJOY BUT DO NOW

CONSUMPTION

TIME

WHAT CHANGED?

DRAW YOUR TOP THREE EDIBLE PLANTS
+ HOW THEY LOOK WHILE GROWING

EXAMPLE

POTATO (SUBTERRANEAN STARCH-SPHERE)

WHAT MAKES YOU REACT
THIS WAY?

WHAT SONG BROUGHT YOU
PEACE AT A TUMULTUOUS
TIME IN YOUR LIFE?

DESCRIBE A TIME YOU REACTED
THIS WAY

WHAT WERE THE LOGICAL
STEPS THAT LED YOU TO YOUR
WORST DECISION EVER?

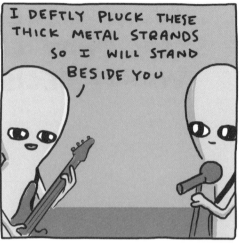

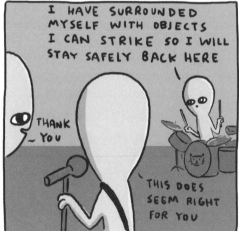

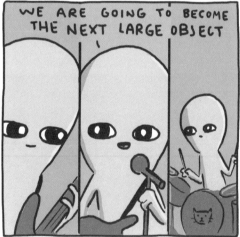

DRAW YOUR BAND LOGO AND DESCRIBE YOUR BAND MEMBERS

WHAT IS THE MUSICAL ACT YOU MOST WANT TO SEE PERFORM AND WHY?

WHAT ONE SONG BY THAT ACT
MOVES YOU THE MOST?

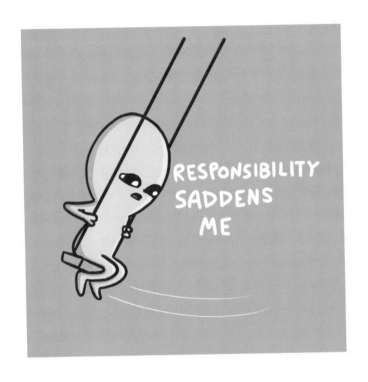

WHAT MAKES YOU REACT
THIS WAY?

WHAT RESPONSIBILITIES DO YOU MOST ENJOY?

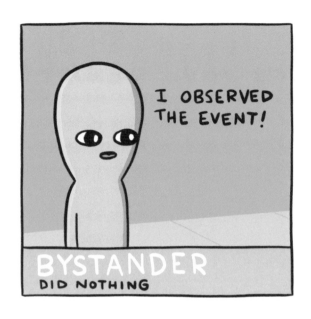

DESCRIBE A TIME YOU REACTED
THIS WAY

WHAT IS THE MOST REMARKABLE
EVENT THAT YOU WITNESSED
IN PERSON?

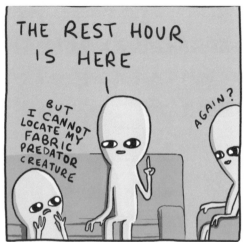

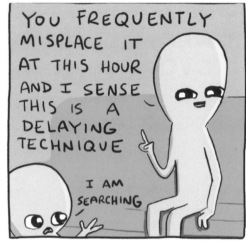

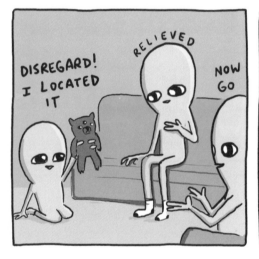

WHAT WAS YOUR MOST TREASURED POSSESSION AS A YOUNG BEING?
DRAW AND DESCRIBE IT

WHAT COMFORTED YOU MOST
AS A YOUNG BEING?

WHAT COMFORTS YOU MOST NOW?
WHAT HAS CHANGED?

WHAT WERE YOU FEELING
WHEN YOU REACTED THIS WAY?

WHAT EXPERIENCE WAS
MORE PAINFUL THAN YOU
EXPECTED?

WHAT MAKES YOU REACT
THIS WAY?

WHAT IS A MEMORABLE EVENT
THAT MADE YOU CHANGE YOUR MIND
ABOUT SOMETHING?

WHAT IS YOUR FAVORITE BOOK
OF ALL TIME?

WHY IS IT YOUR FAVORITE?

WHO IS THE BOOK CHARACTER YOU MOST RELATE TO? DRAW AND DESCRIBE THEM

LABEL THE CRUCIAL ELEMENTS

WHY DO YOU RELATE SO MUCH TO THIS CHARACTER?

WHAT MAKES YOU REACT THIS WAY?

WHO IS THE BEING THAT MOST
SOOTHES YOUR ANXIETIES
AND WHY?

DESCRIBE A TIME YOU REACTED THIS WAY

HOW CHAOTIC OF A YOUNG BEING WERE YOU?

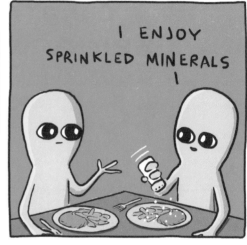

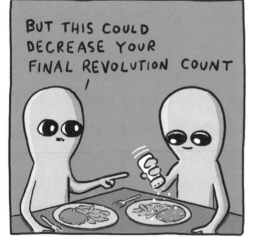

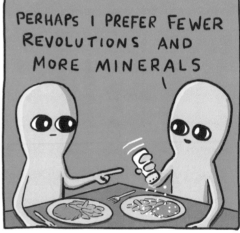

WHAT IS YOUR FAVORITE SEASONING AND HOW DO YOU INGEST IT?

WHAT MEAL IS THE MOST
QUINTESSENTIALLY YOU?
DRAW AND DESCRIBE IT.

RANK YOUR TOP TEN
SAUCES

1

2

3

4

5

6

7

8

9

10

HONORABLE MENTIONS:

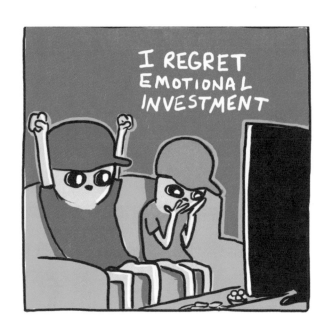

WHAT WERE YOU FEELING
WHEN YOU REACTED THIS WAY?

WHAT EMOTIONAL INVESTMENT
DO YOU MOST REGRET?

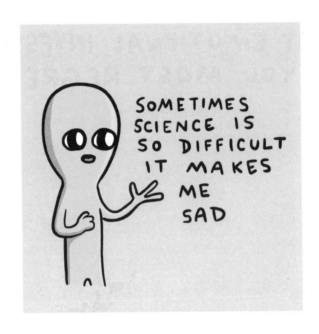

WHAT MAKES YOU REACT
THIS WAY?

WHAT SCIENTIFIC ADVANCEMENTS
DO YOU MOST WANT TO SEE IN
YOUR LIFETIME?

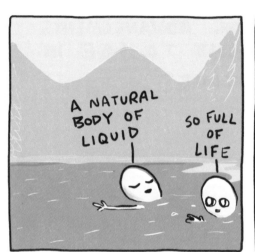
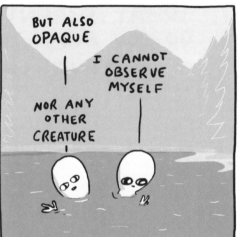
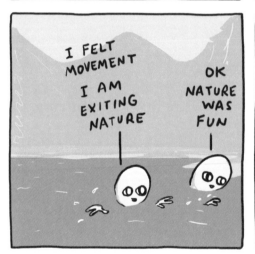
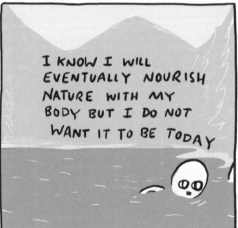

DESCRIBE YOUR MOST
UNSETTLING ENCOUNTER
WITH AN UNKNOWN CREATURE

DESCRIBE YOUR IDEAL
2-DAY RESPONSIBILITY ESCAPE
DAY 1

STAR
RISE

MID
DAY

STAR
FADE

DAY 2

STAR
RISE

MID
DAY

STAR
FADE

WHAT MAKES YOU REACT
THIS WAY?

WHAT WAS THE MOST DANGEROUS
STUNT YOU TRIED AS A
YOUNG BEING?

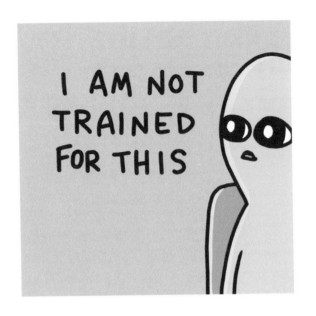

DESCRIBE A TIME YOU REACTED
THIS WAY

IF YOU COULD GO BACK AND
RECEIVE A SPECIFIC TRAINING,
WHAT WOULD IT BE?

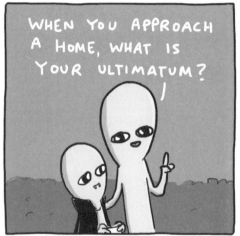

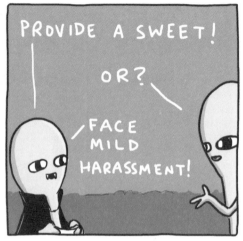

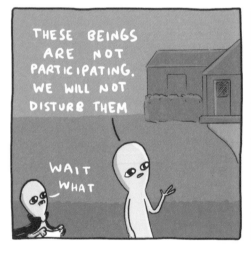

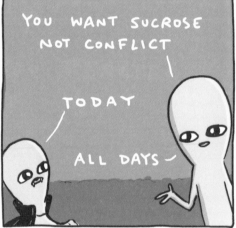

DRAW AND DESCRIBE YOUR FAVORITE HALLOWEEN COSTUME

LABEL THE CRUCIAL ELEMENTS

RANK YOUR TOP FIVE
HALLOWEEN CANDIES
DEFEND YOUR CHOICES

#1

#2

#3

#4

#5

DRAW AND DESCRIBE A FUTURE HALLOWEEN COSTUME

LABEL THE CRUCIAL ELEMENTS

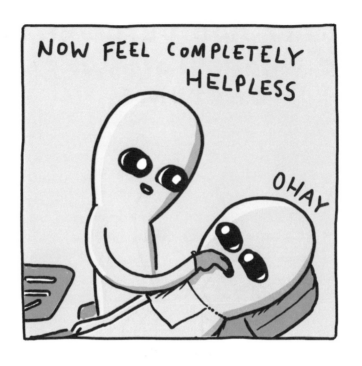

WHAT MAKES YOU REACT
THIS WAY?

WHEN DID YOU FEEL THE MOST HELPLESS?

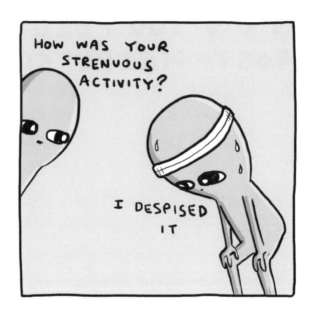

WHAT WERE YOU FEELING
WHEN YOU REACTED THIS WAY?

DESCRIBE A GOAL THAT YOU
ACHIEVED THAT REQUIRED YOU
TO PUSH YOURSELF

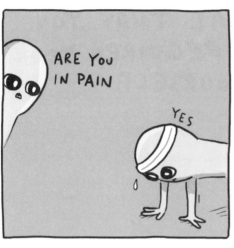

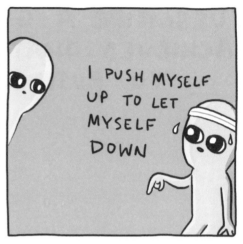

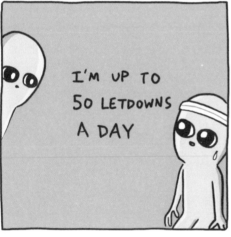

WHAT IS CURRENTLY
MOTIVATING YOU?

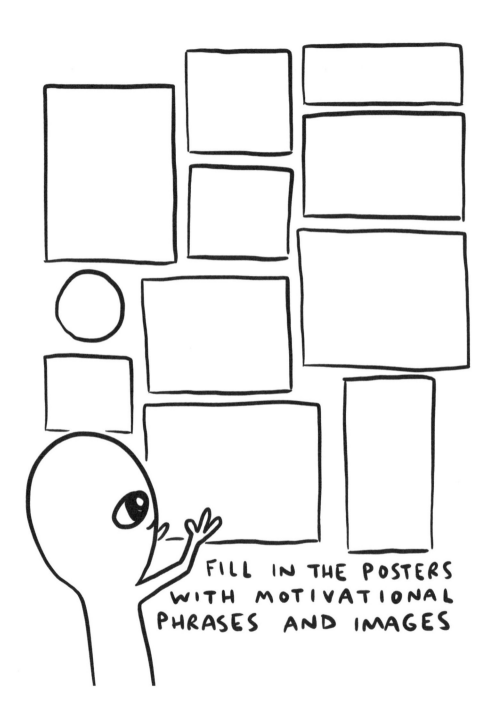

FILL IN THE POSTERS WITH MOTIVATIONAL PHRASES AND IMAGES

LIST SOME OF YOUR GOALS
CHECK THEM OFF WHEN COMPLETE

- []
- []
- []
- []
- []
- []
- []

DESCRIBE A TIME YOU REACTED
THIS WAY

WHAT ARE THE BEST
ACTIONS YOU CAN TAKE FOR
YOURSELF WHEN YOU ARE
EMOTIONALLY DISTRESSED?

WHAT MAKES YOU REACT
THIS WAY?

WHAT SONG TAKES YOU BACK TO A SPECIFIC DATE AND TIME AND WHY?

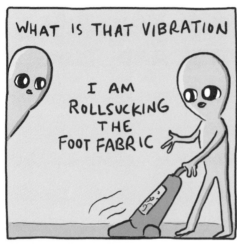

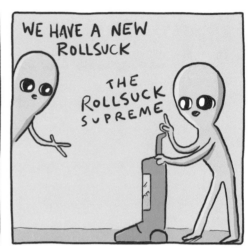

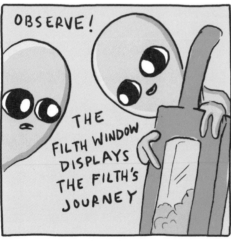

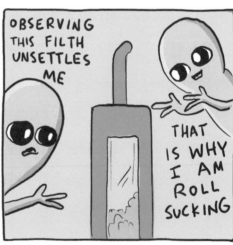

DRAW A FOUR-PANEL COMIC
ABOUT YOU AND ANOTHER BEING
HAVING A MINOR DISAGREEMENT
ABOUT A HOUSEHOLD TASK

WRITE YOUR TO-DO LIST

WRITE YOUR TO-DO LIST
AS THE BEINGS WOULD
DESCRIBE IT

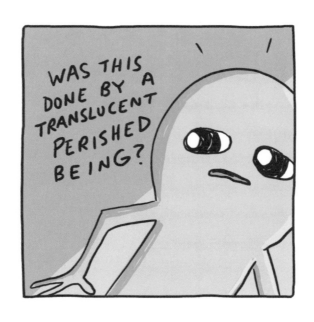

DESCRIBE A TIME YOU REACTED
THIS WAY

WHAT IS A PHENOMENON
YOU EXPERIENCED THAT IS
INEXPLICABLE?

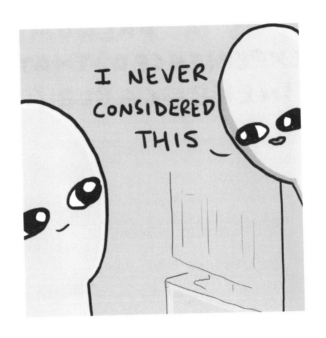

WHAT MAKES YOU REACT
THIS WAY?

WHAT IS SOMETHING YOU
NEVER THOUGHT YOU WOULD
EXPERIENCE BUT THEN DID?

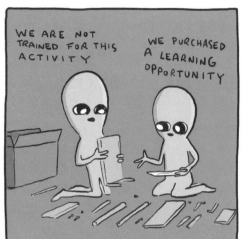

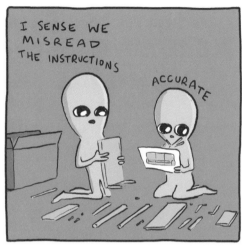

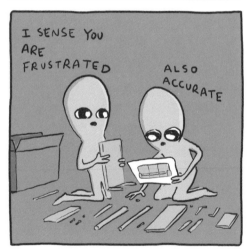

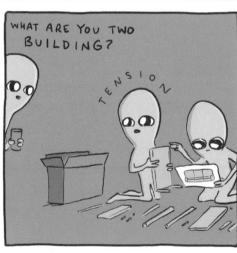

DESCRIBE A TIME YOU
ACCOMPLISHED A TASK THAT YOU
WERE NOT TRAINED FOR

DRAW AND DESCRIBE THE PHYSICAL CONSTRUCTION PROJECT YOU ARE MOST PROUD OF

DRAW A FOUR-PANEL COMIC
DESCRIBING A PROBLEM YOU
ENCOUNTERED AND SOLVED

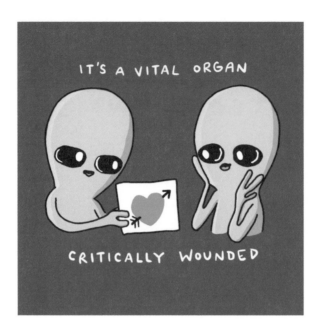

WHAT WERE YOU FEELING
WHEN YOU REACTED THIS WAY?

DESCRIBE A TIME YOUR
VITAL ORGAN WAS
WOUNDED

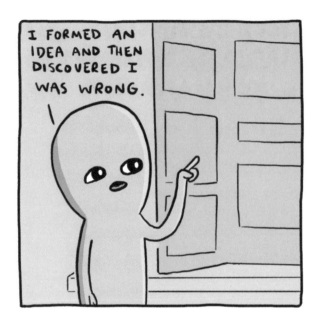

WHAT WERE YOU FEELING
WHEN YOU REACTED THIS WAY?

DESCRIBE ANOTHER BEING
WHO HELPED YOU REALIZE
YOU WERE WRONG ABOUT
SOMETHING

WHAT ARE YOUR FIVE FAVORITE HOUSEHOLD TASKS (CHORES)?

WHAT ARE YOUR FIVE LEAST
FAVORITE HOUSEHOLD TASKS
(CHORES)?

IF YOU COULD DESIGN THE
PERFECT MACHINE TO MAKE
HOUSEHOLD WORK EASIER,
WHAT WOULD IT DO?

WHAT MAKES YOU REACT THIS WAY?

WHAT IS YOUR FAVORITE
FICTIONAL CREATURE
AND WHY?

DESCRIBE A TIME YOU REACTED THIS WAY

DESCRIBE YOUR MOST
MEMORABLE ATTEMPT AT
SCIENCE

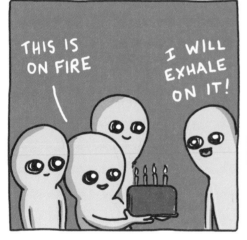

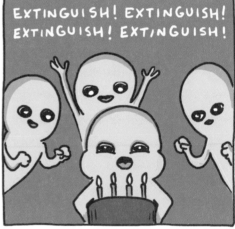

WHAT ARE YOUR FAVORITE
EMERGENCE DAY TRADITIONS?

LIST THE EMERGENCE DAYS
OF YOUR FAVORITE BEINGS

DRAW AND DESCRIBE THE
EMERGENCE DAY SUSTENANCE
YOU TRADITIONALLY INGEST

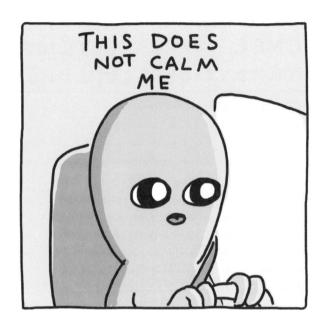

WHAT MAKES YOU REACT
THIS WAY?

WHAT IS THE LEAST
CALMING SCIENTIFIC FACT
YOU KNOW?

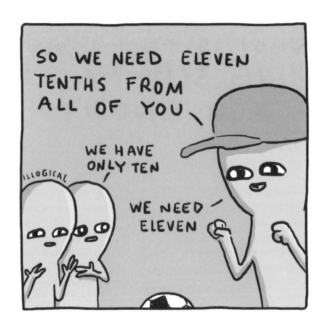

WHAT WERE YOU FEELING
WHEN YOU REACTED THIS WAY?

WHEN DID YOU EXPECT TOO
MUCH OF SOMEONE ELSE?

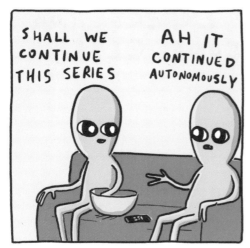

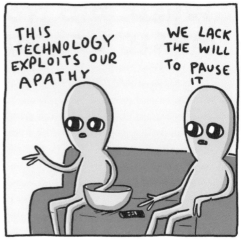

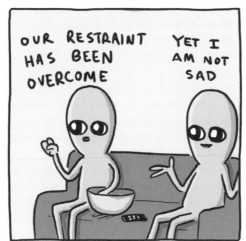

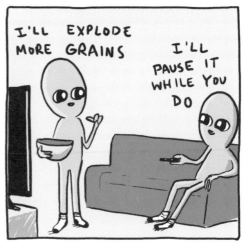

WHAT IS THE BEST TV SERIES
OF ALL TIME (IN YOUR OPINION)?

WHY IS IT THE BEST?

WHO IS THE TV CHARACTER
YOU MOST RELATE TO?
DRAW AND DESCRIBE THEM

LABEL THE CRUCIAL ELEMENTS

WHY DO YOU RELATE SO MUCH
TO THIS CHARACTER?

WHAT WERE YOU FEELING
WHEN YOU REACTED THIS WAY?

WHAT IS YOUR FAVORITE
MOUTHPUSH IN A FICTIONAL
NARRATIVE AND WHY?

WHAT MAKES YOU REACT
THIS WAY?

WHAT COULD YOU OBSERVE
EVERY DAY? MAKE A LIST

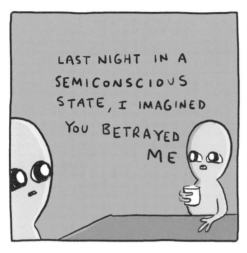

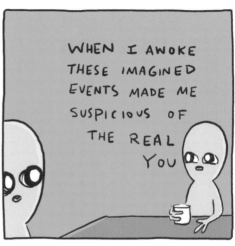

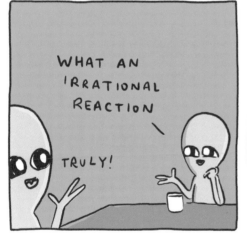

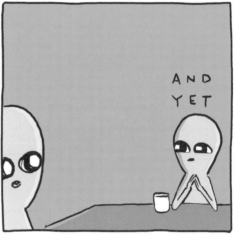

DOCUMENT THE EVENTS YOU IMAGINE IN A SEMICONSCIOUS STATE

DRAW

DESCRIBE

SCENE 1

SCENE 2

SCENE 3

RATE THE OVERALL EVENTS

UNPLEASANT

PLEASANT

DRAW

DESCRIBE

SCENE 1

SCENE 2

SCENE 3

RATE THE OVERALL EVENTS

UNPLEASANT

PLEASANT

DOCUMENT THE EVENTS YOU IMAGINE IN A SEMICONSCIOUS STATE

DRAW

DESCRIBE

SCENE 1

SCENE 2

SCENE 3

RATE THE OVERALL EVENTS

UNPLEASANT

PLEASANT

DRAW

DESCRIBE

SCENE 1

SCENE 2

SCENE 3

RATE THE OVERALL EVENTS

UNPLEASANT

PLEASANT

DESCRIBE A TIME YOU REACTED THIS WAY

WHAT ARE SOME FACTS YOU
REMEMBER IN DETAIL FROM
YOUR EARLY EDUCATION?

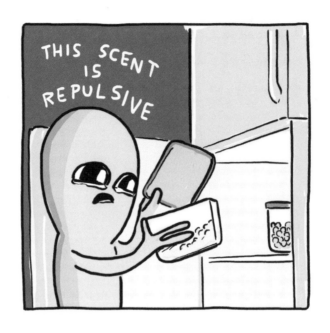

WHAT MAKES YOU REACT
THIS WAY?

WHAT IS THE WORST FOOD-RELATED SCENT YOU HAVE EVER EXPERIENCED?

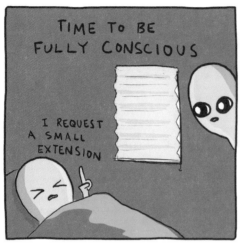

WHEN DO YOU NORMALLY
BECOME FULLY CONSCIOUS?

MARK WITH AN X

EARLY ⊢—+—+—+—+—+—+—+—+—⊣ LATE

HOW HAS THIS CHANGED
OVER THE REVOLUTIONS?

IF YOU HAD UNLIMITED TIME
AND NO RESPONSIBILITIES,
WHAT WOULD YOUR MORNING
ROUTINE LOOK LIKE?

WHAT DOES YOUR MORNING ROUTINE ACTUALLY LOOK LIKE?

WHAT WERE YOU FEELING
WHEN YOU REACTED THIS WAY?

WHAT INANIMATE OBJECT
DO YOU GET IRRATIONALLY
ANGRY AT?

DESCRIBE A TIME YOU REACTED
THIS WAY

WHAT IS YOUR FAVORITE
SUSTENANCE ROUTINE WHEN
WATCHING MOVIES?

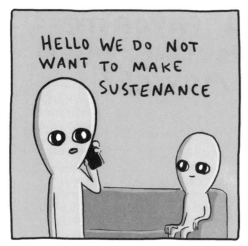

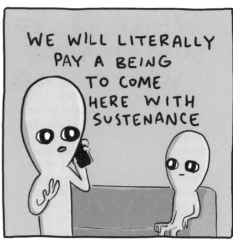

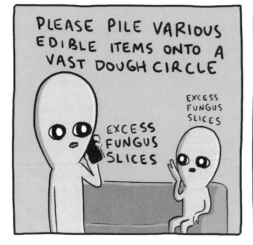

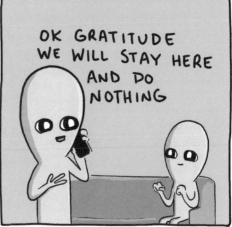

DRAW YOUR IDEAL VAST DOUGH CIRCLE

DESCRIBE THE BEST DOUGH CIRCLE
ESTABLISHMENT YOU HAVE BEEN TO

DESCRIBE YOUR FAVORITE SUSTENANCE DELIVERY & CONSUMPTION RITUAL:

DRAW AND LABEL THE SEQUENCE

1	2

3	4

You ARE CREATING A UNIQUE
SUSTENANCE DELIVERY ESTABLISHMENT.
DESCRIBE WHAT YOU MAKE AND HOW
YOU DELIVER IT.

WHAT MAKES YOU REACT
THIS WAY?

WHAT IS THE MOST ABSURD
EFFORT YOU HAVE MADE IN
THE NAME OF EFFICIENCY?

WHAT WERE YOU FEELING
WHEN YOU REACTED THIS WAY?

DESCRIBE A TIME YOU
VERY SLOWLY REALIZED
YOU MADE A MISTAKE

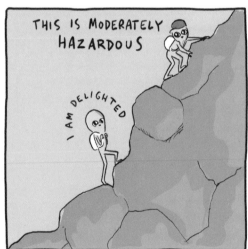

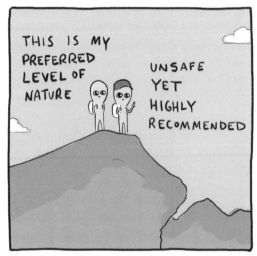

DRAW AND DESCRIBE THE THREE BEST NATURAL VISTAS YOU'VE OBSERVED

DESCRIBE IN DETAIL A DANGEROUS
ACTIVITY YOU ENGAGED IN AND HOW
IT MADE YOU FEEL

LIST THE MOST CRUCIAL RULES YOU LEARNED FOR SURVIVING THIS ACTIVITY

①

②

③

④

⑤

⑥

WHAT MAKES YOU REACT
THIS WAY?

WHAT IS A PARADIGM SHIFT YOU EXPERIENCED THAT CHANGED YOUR WORLD?

WHAT WERE YOU FEELING
WHEN YOU REACTED THIS WAY?

WHAT ARE MOST VIVID
MEMORIES OF STAYING
HOME FROM SCHOOL?

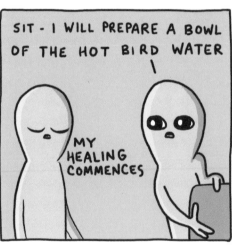

DESCRIBE YOUR BEST PRACTICES
WHEN YOU ARE FEELING
SUBOPTIMAL

DRAW AND DESCRIBE
FAVORITE SUBOPTIMAL-TIMES MEAL

DRAW AND DESCRIBE THE THREE
MOST CRUCIAL ITEMS YOU
NEED DURING THIS TIME

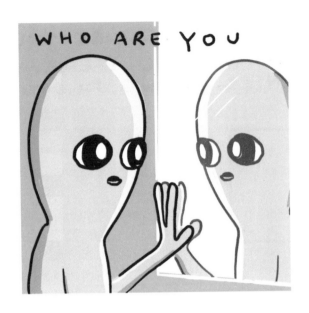

DESCRIBE A TIME YOU REACTED
THIS WAY

WHAT CHARACTERISTIC OF CURRENT YOU WOULD BE MOST SURPRISING TO PAST YOU?

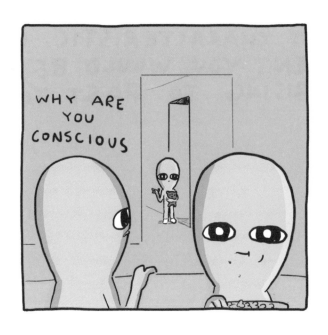

WHAT WERE YOU FEELING
WHEN YOU REACTED THIS WAY?

WHAT WAS YOUR FAVORITE
REST-DELAYING DIVERSION AS
A YOUNG BEING?

DESCRIBE YOUR REST-SLAB
ROUTINE WHEN YOU WERE A
YOUNG BEING

DESCRIBE YOUR REST-SLAB
ROUTINE NOW

DRAW YOUR CHILDHOOD BEDROOM

LIST THE CRUCIAL ELEMENTS

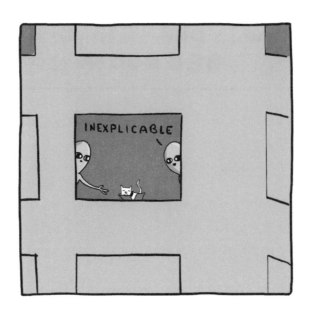

DESCRIBE A TIME YOU REACTED
THIS WAY

WHAT DO YOU FIND
INEXPLICABLE?

WHAT WERE YOU FEELING
WHEN YOU REACTED THIS WAY?

DESCRIBE THE ABSOLUTE
COZIEST SETUP YOU CAN
THINK OF

DESCRIBE A TIME IN YOUR LIFE
WHEN YOU WERE DEEPLY SAD

WHAT OR WHO HELPED
YOU IN THIS TIME?

DESCRIBE A TIME WHEN
YOU HELPED ANOTHER BEING
WHO WAS SAD

DESCRIBE A TIME YOU REACTED
THIS WAY

WHO IS THE BEING YOU MOST
TRUST TO GIVE YOU VALIDATION?

WHAT MAKES YOU REACT
THIS WAY?

WHAT WAS THE MOST STUNNING
EMAIL YOU HAVE EVER
RECEIVED?

DRAW AND LABEL SOME
ACCESSORIES YOU OFTEN
WORE AS A YOUNG BEING

DRAW AND LABEL SOME
ACCESSORIES YOU OFTEN
WEAR NOW

WHAT ARTISTRY ARE YOU MOST PROUD OF AND WHY?

WHAT WERE YOU FEELING
WHEN YOU REACTED THIS WAY?

WHAT CREATURE DID YOU
FORM THE STRONGEST EMOTIONAL
ATTACHMENT TO?

DESCRIBE A TIME YOU REACTED
THIS WAY

DESCRIBE YOUR WORST
SUSTENANCE-RELATED INJURY

SPACE FOR UNPROMPTED THOUGHTS

SPACE FOR UNPROMPTED THOUGHTS

SPACE FOR UNPROMPTED THOUGHTS

SPACE FOR UNPROMPTED THOUGHTS

FIRST EDITION

LIBRARY OF CONGRESS
CATALOGING-IN-PUBLICATION DATA
HAS BEEN APPLIED FOR.

ISBN 978-0-06-302270-6
20 21 22 23 24 IMG 10 9 8 7 6 5 4 3 2 1